K-12 Coloring Book

CONCEIVED BY

Melanie Martinez

ILLUSTRATED BY

Nikola Crnobrnja

ULYSSES PRESS

Published by:
ULYSSES PRESS
P.O. Box 3440
Berkeley, CA 94703
www.ulyssespress.com

ISBN: 978-1-64604-307-1

Printed in Canada by Marquis Book Printing

4 6 8 10 9 7 5 3

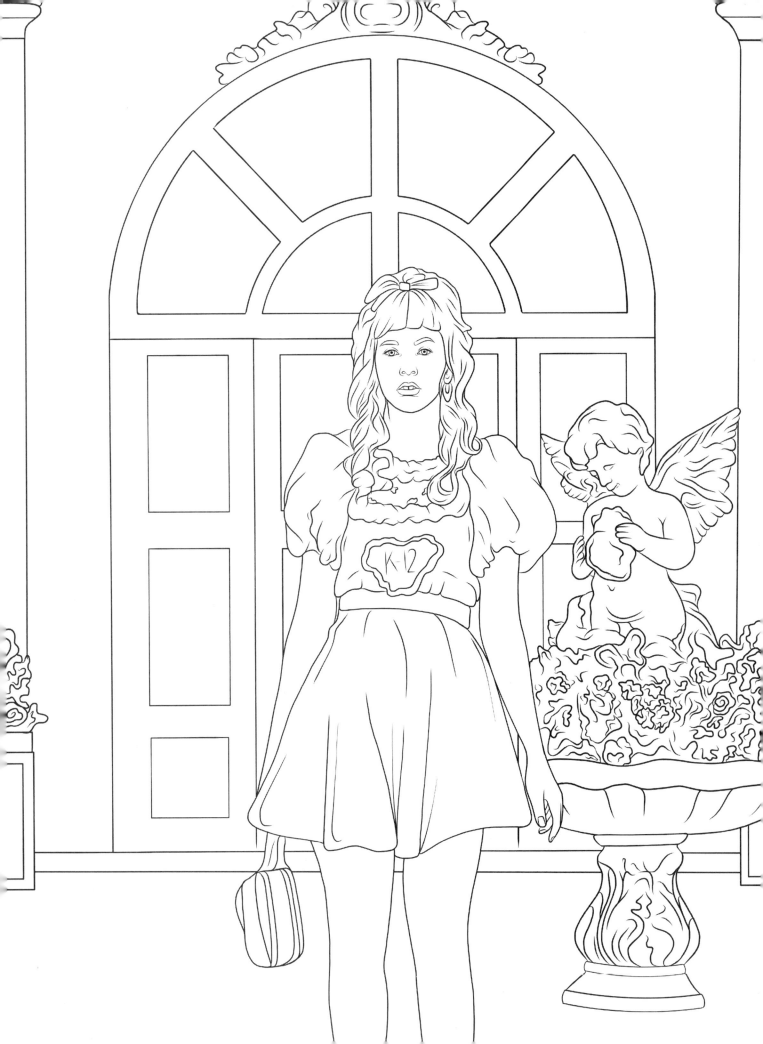

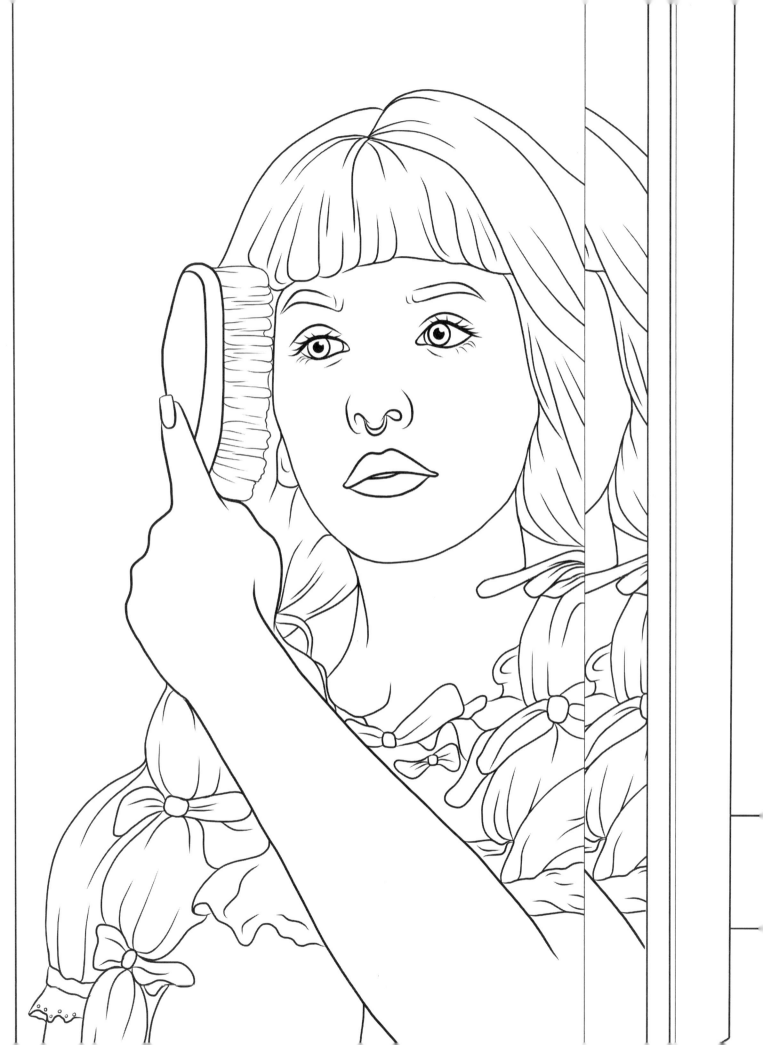

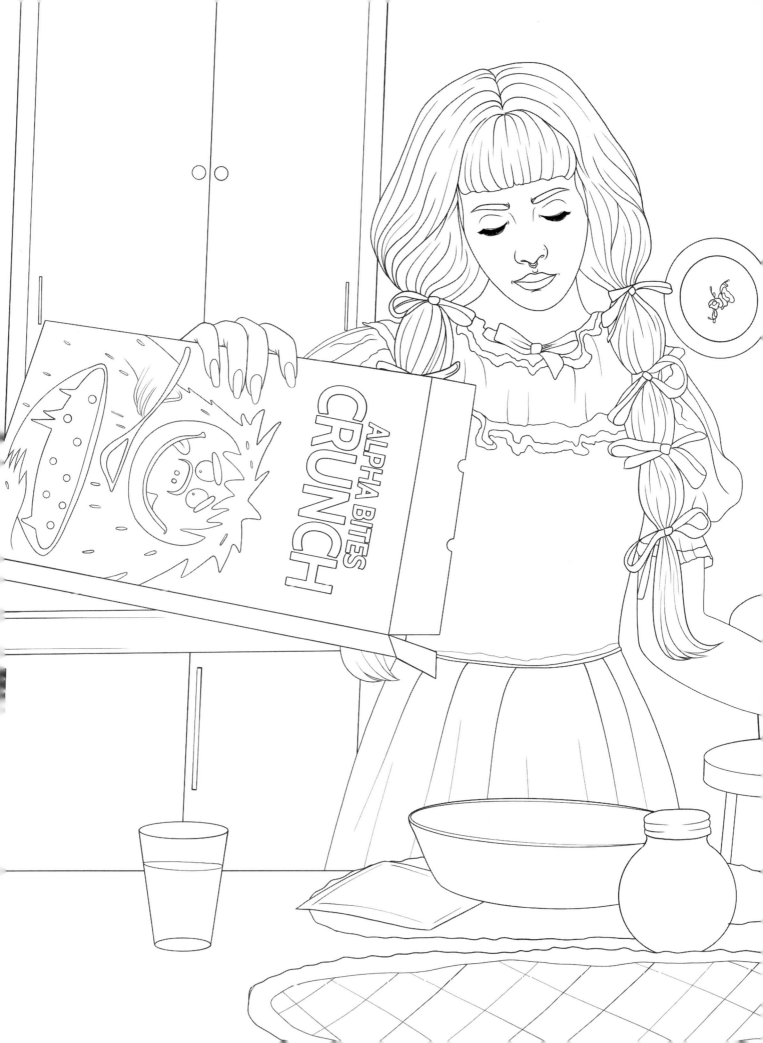

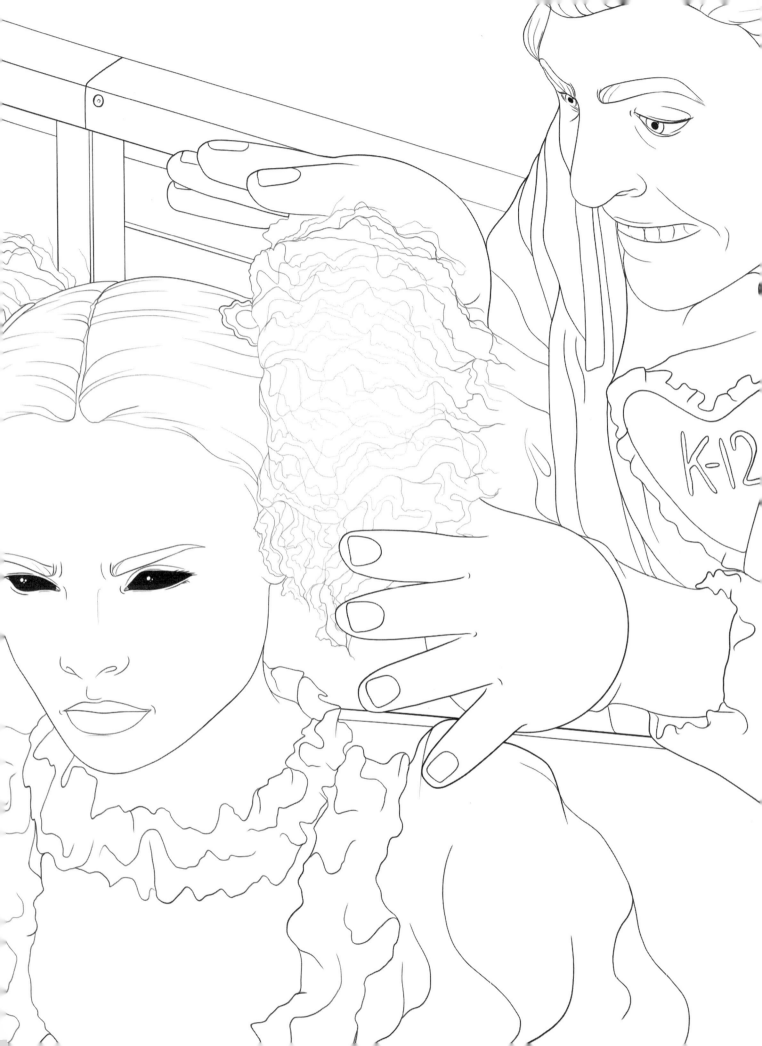

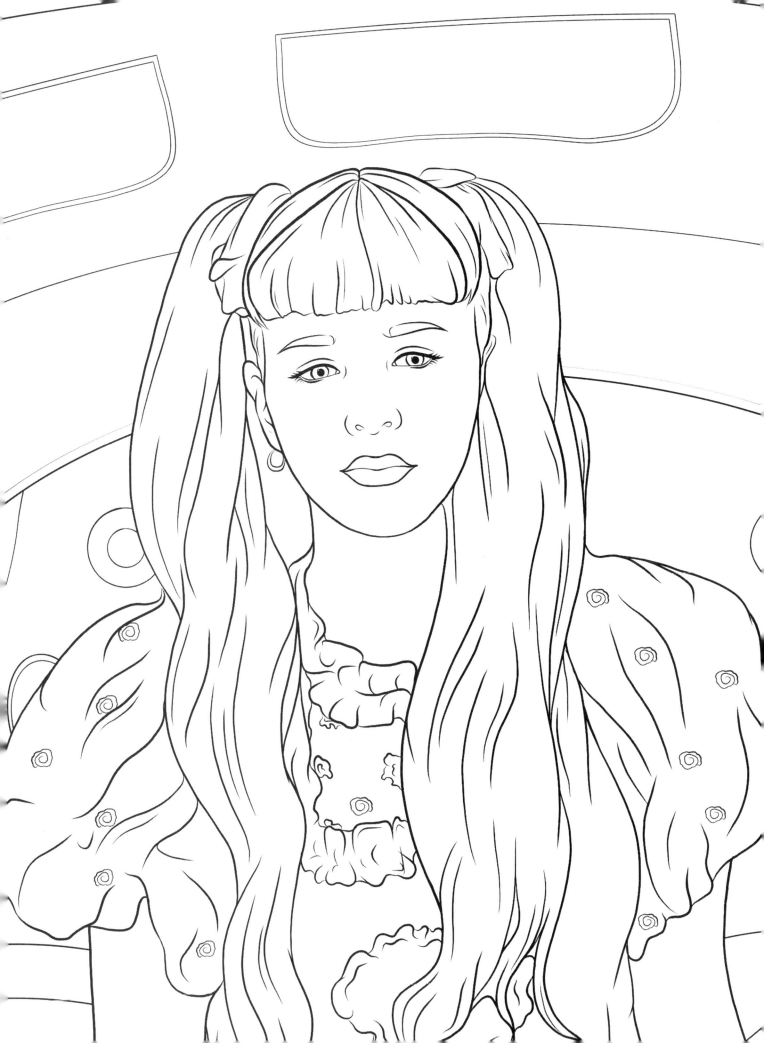

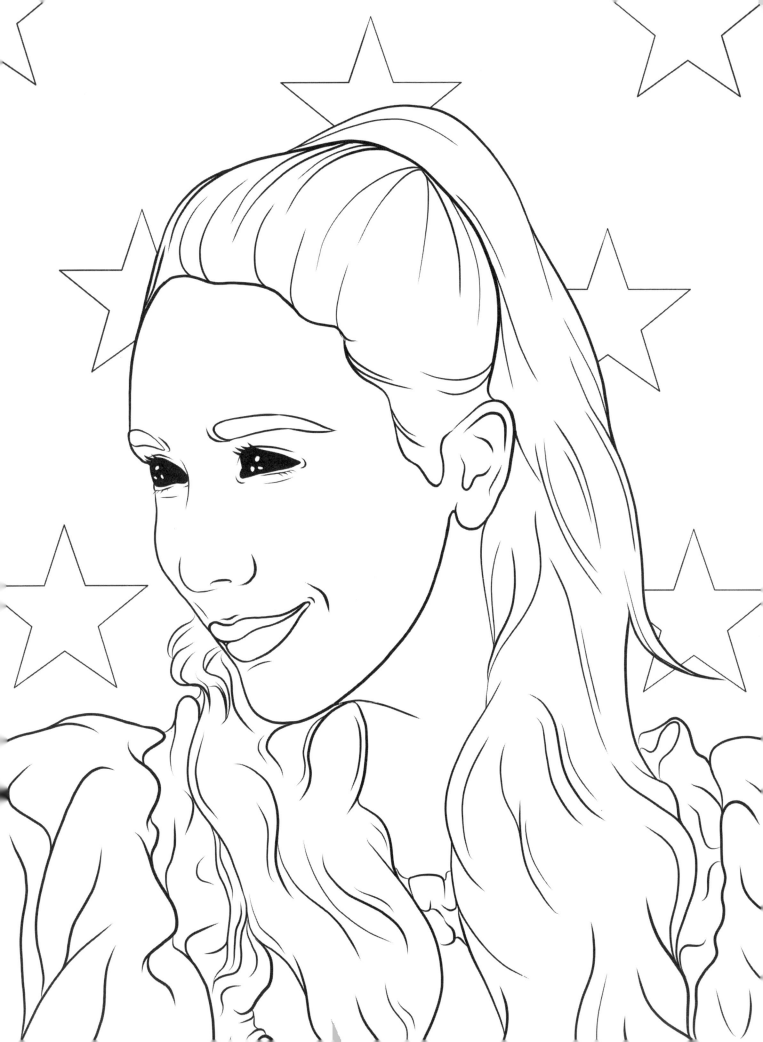

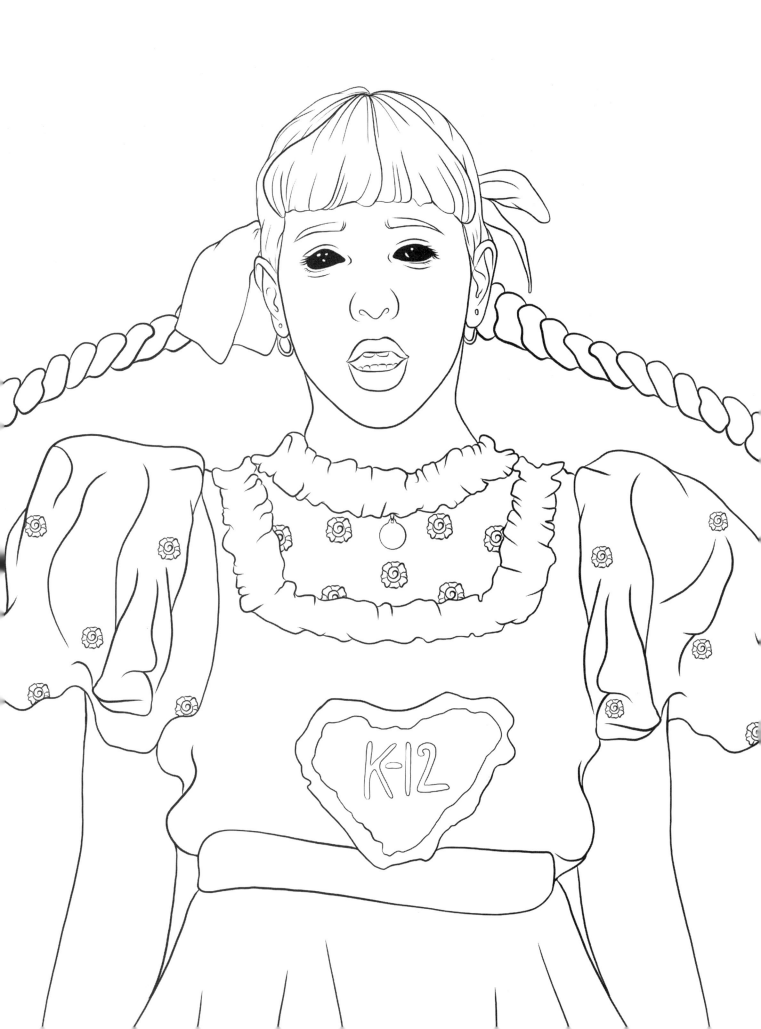

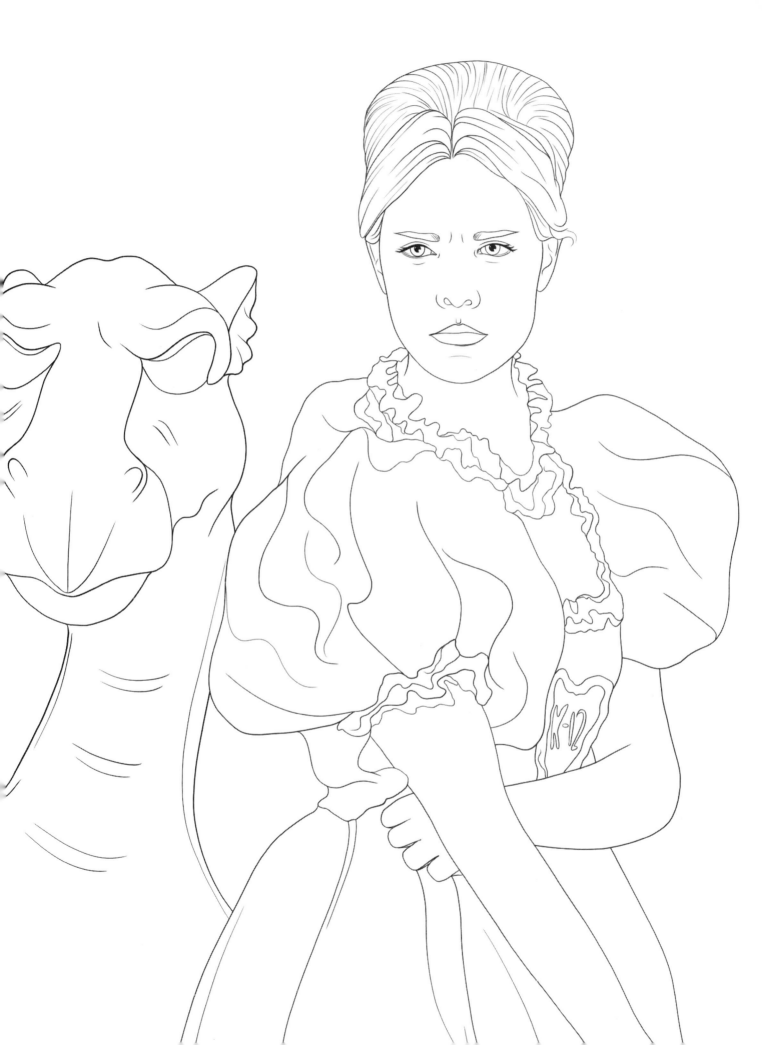

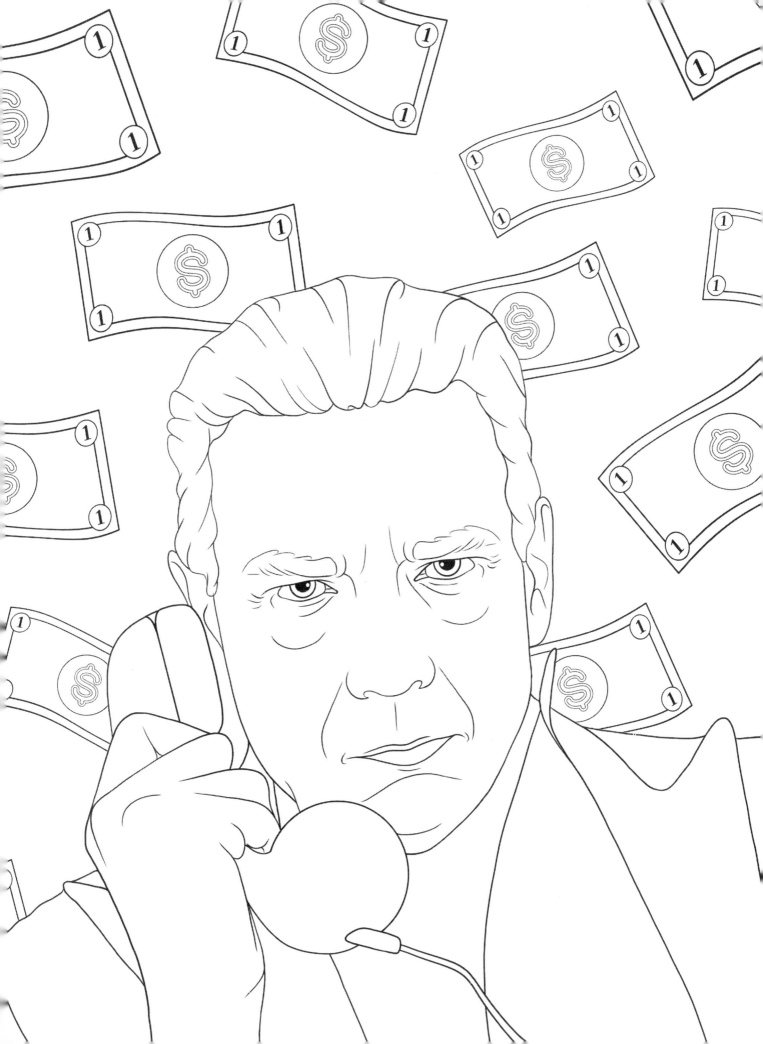

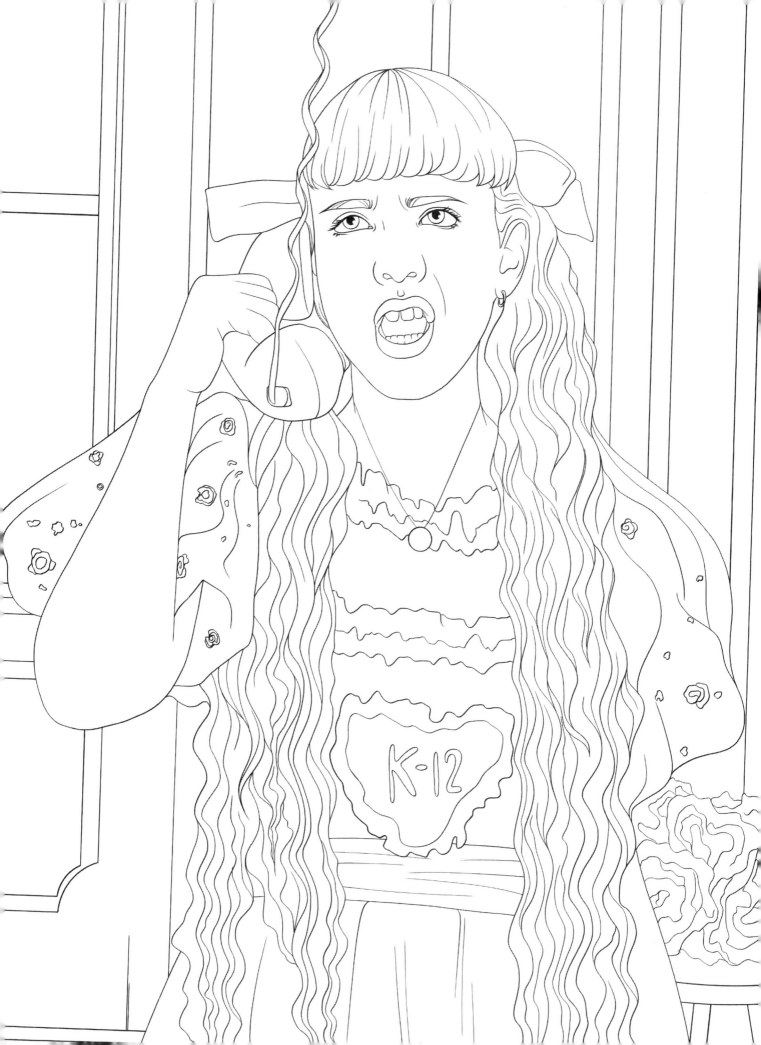

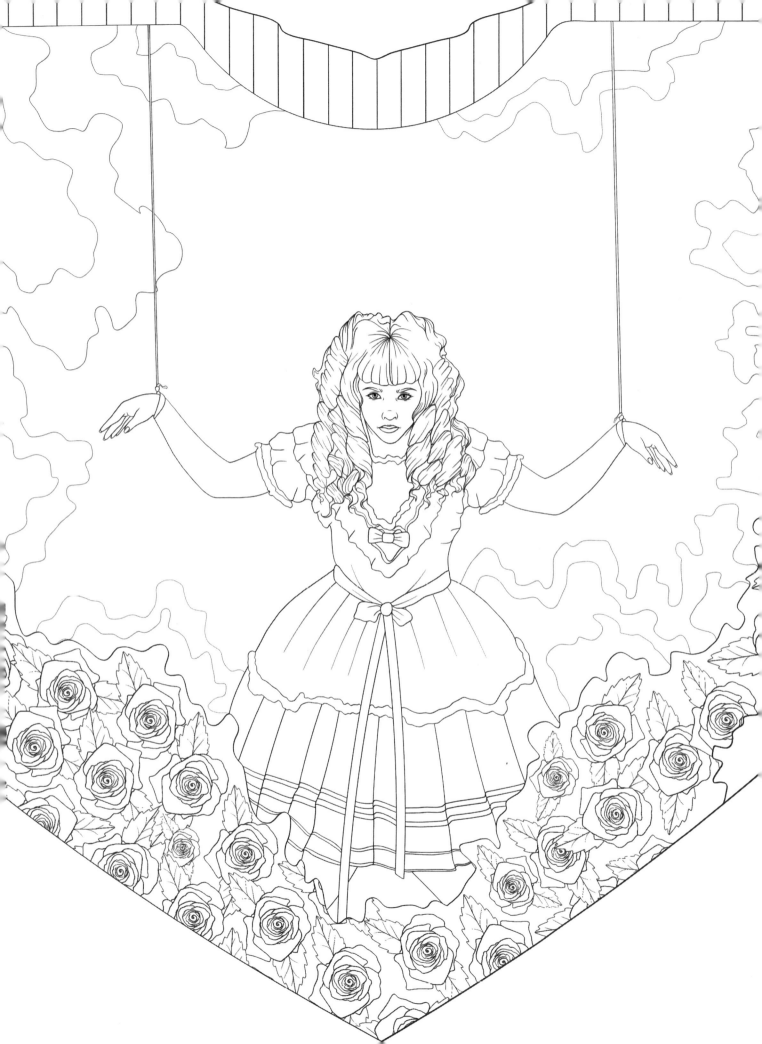

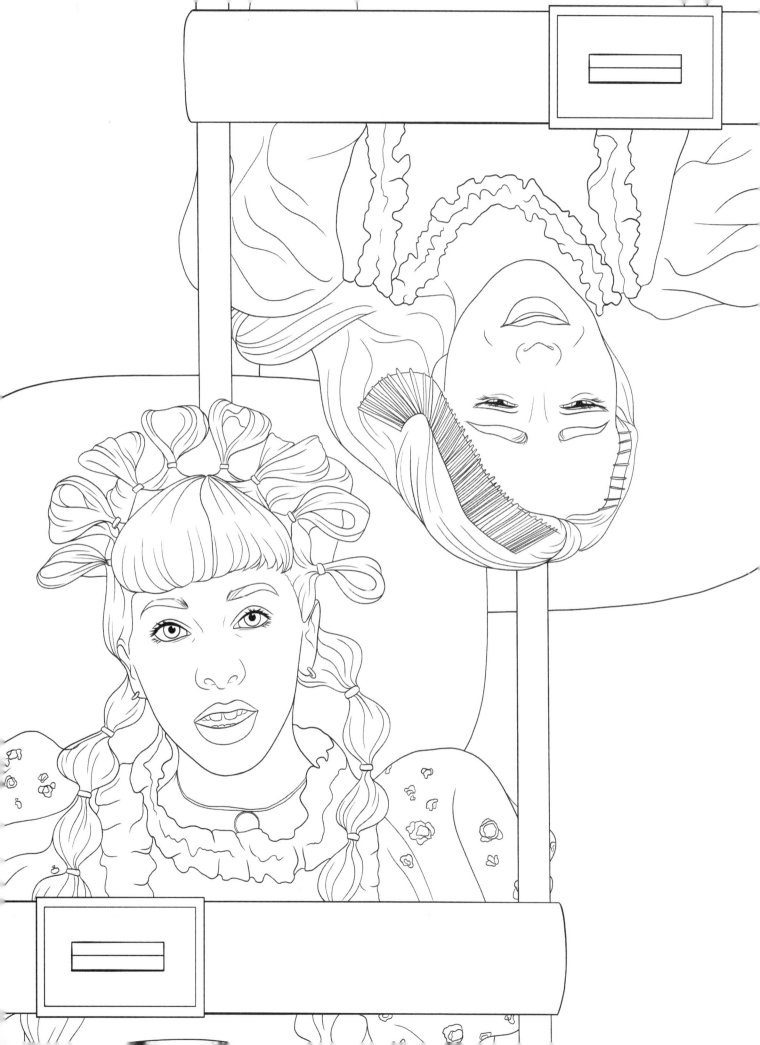

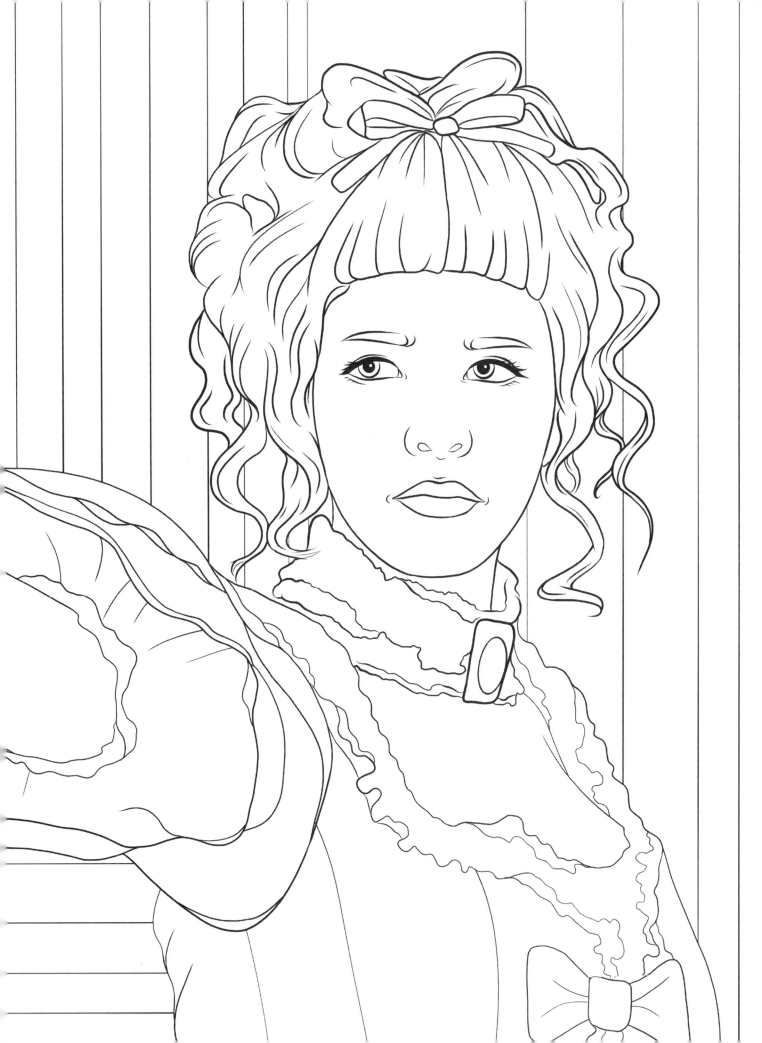

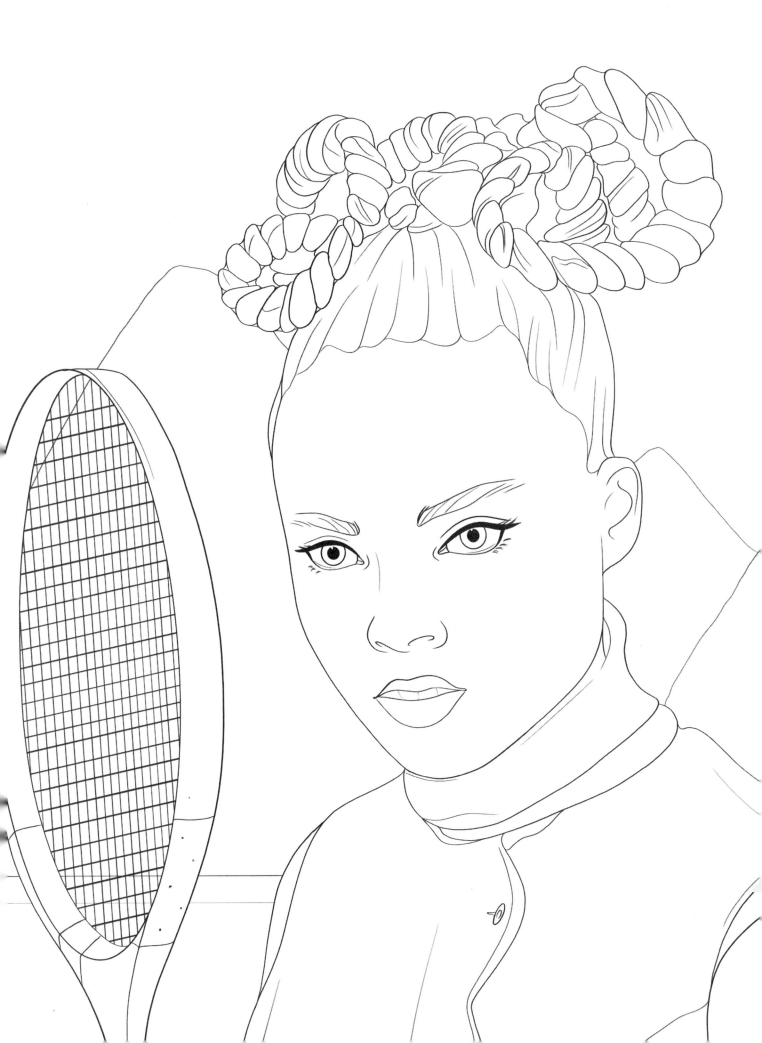

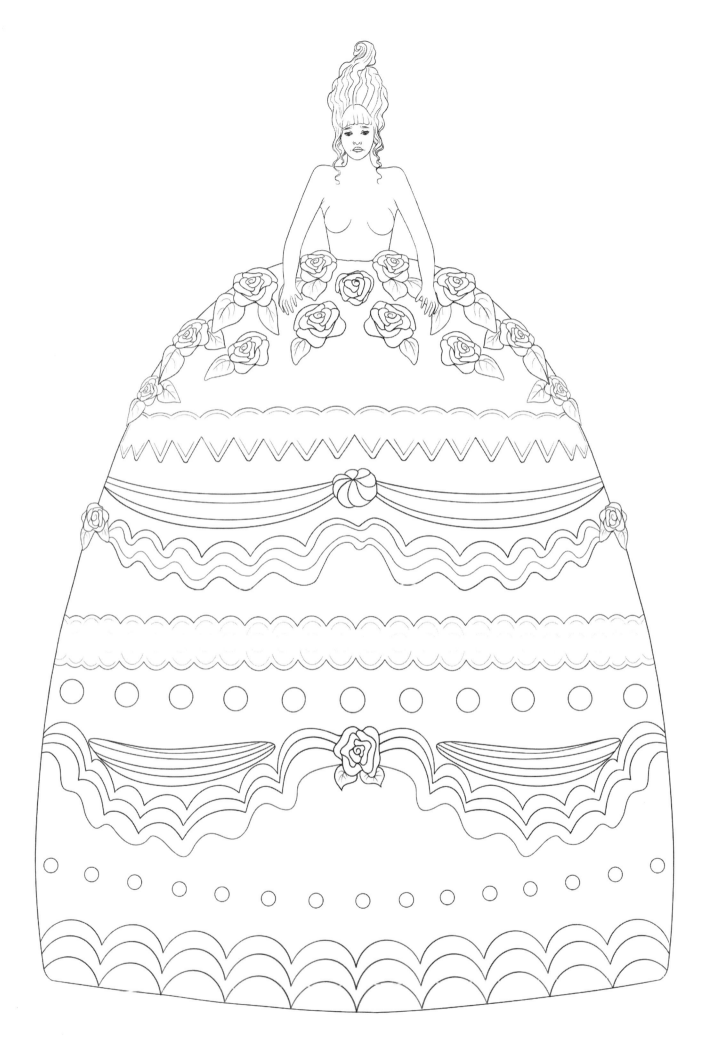

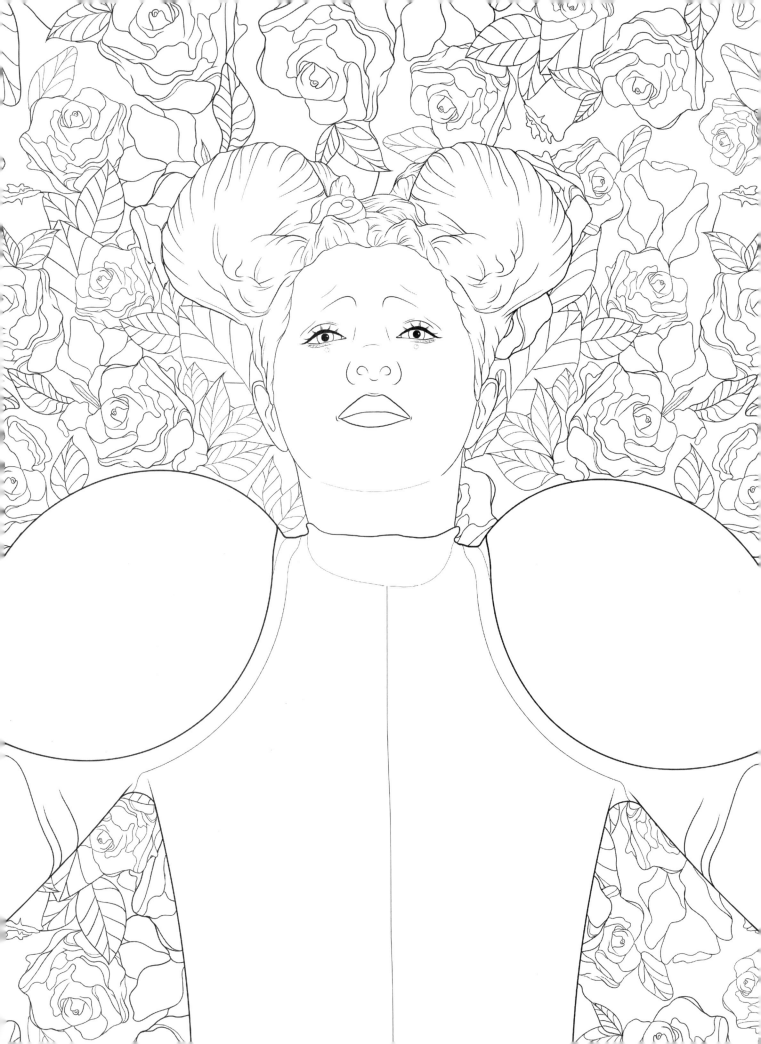

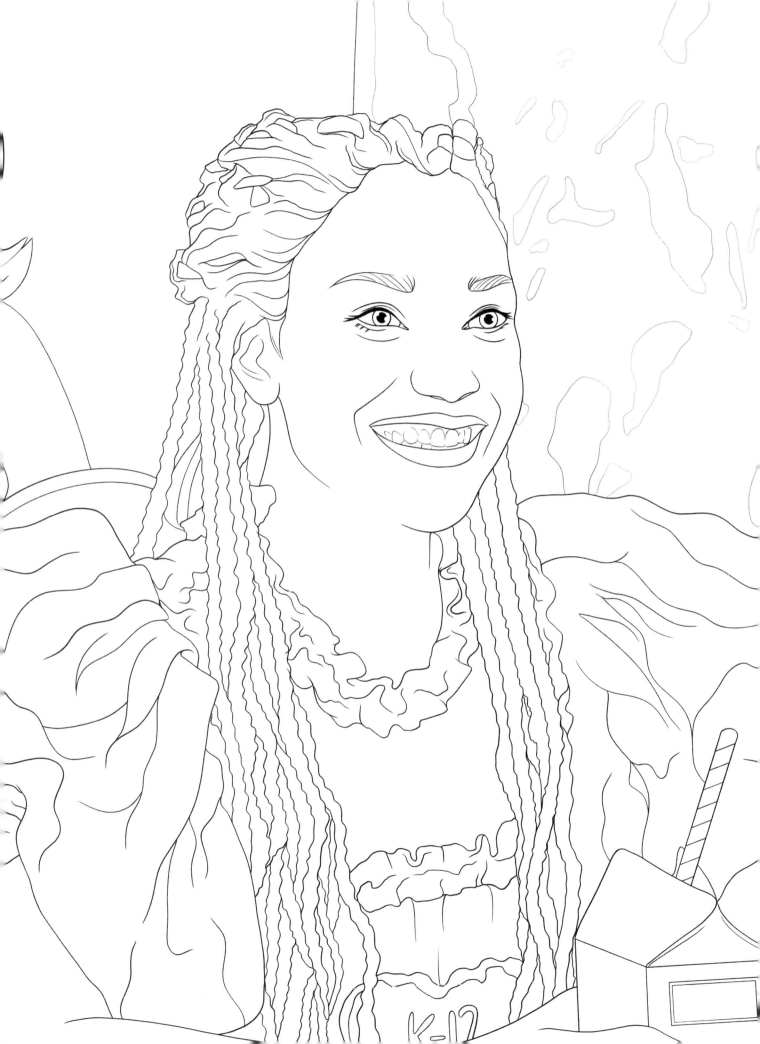

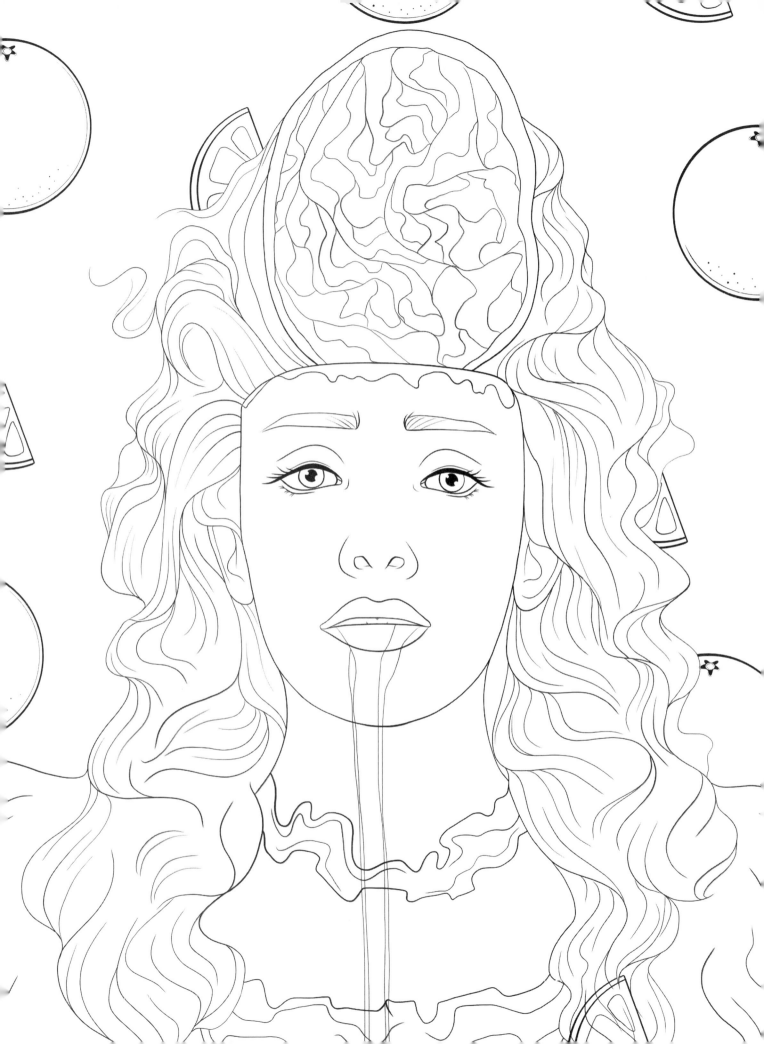

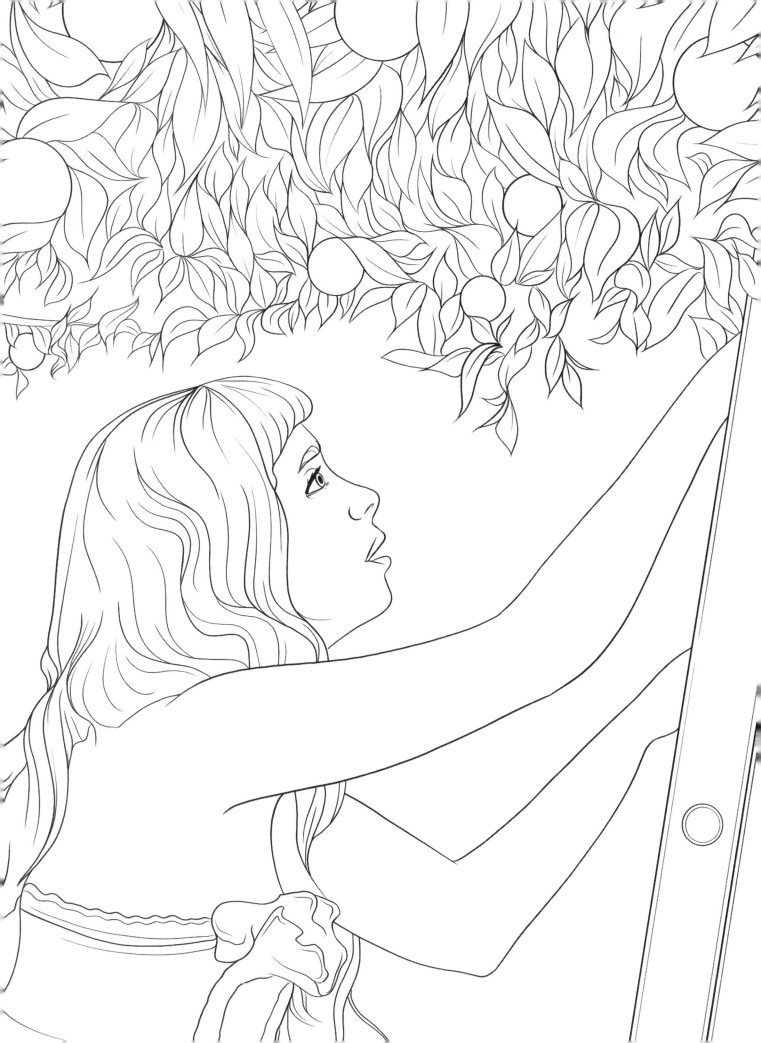

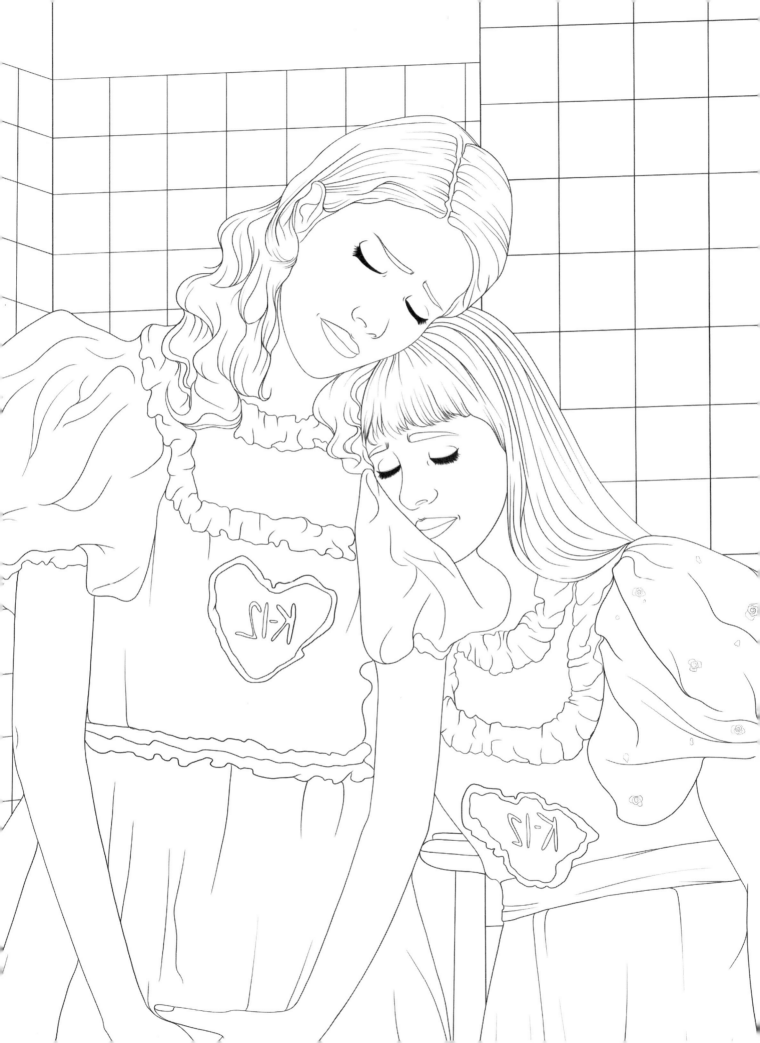

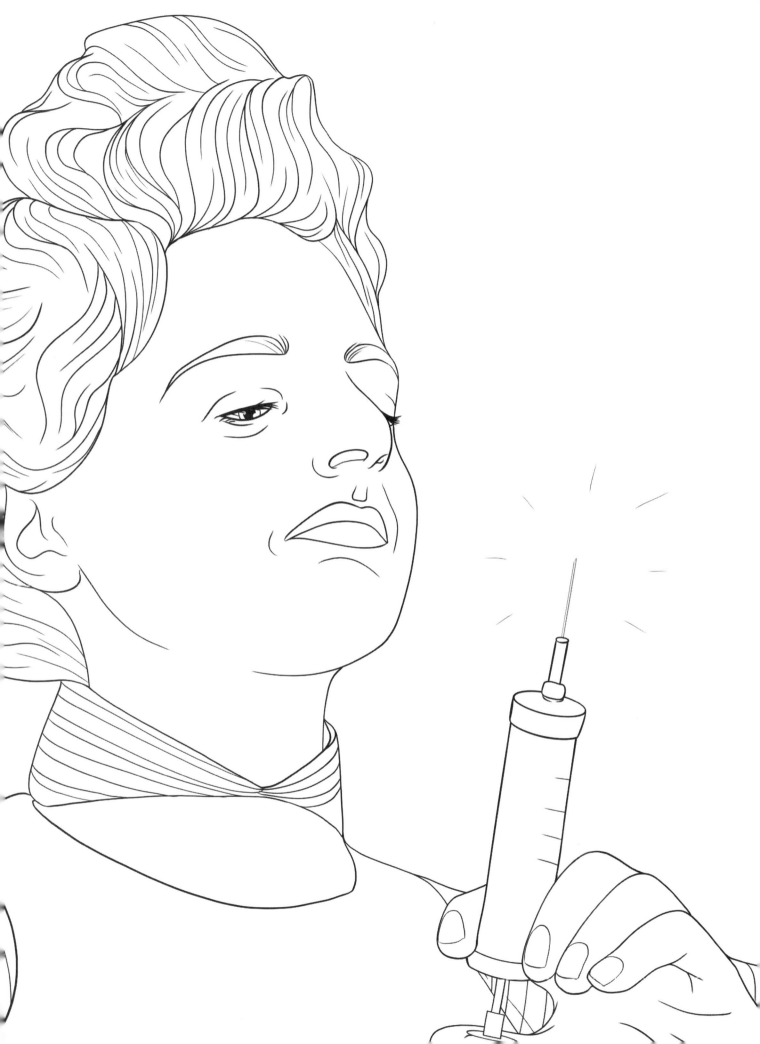

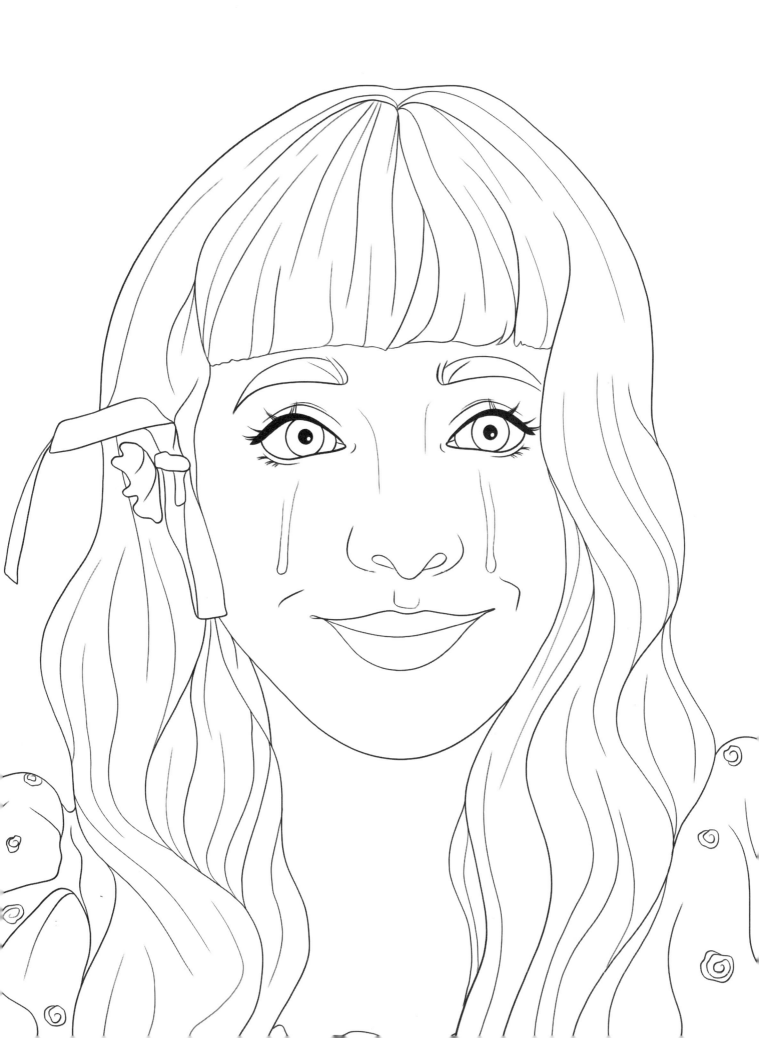

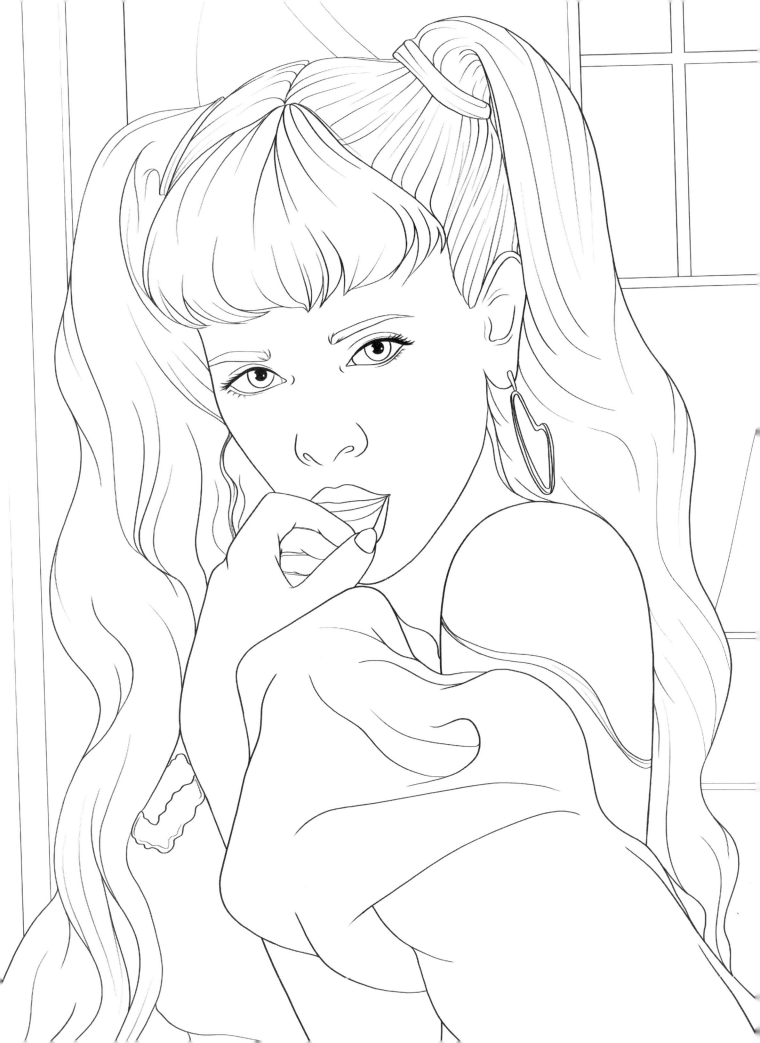

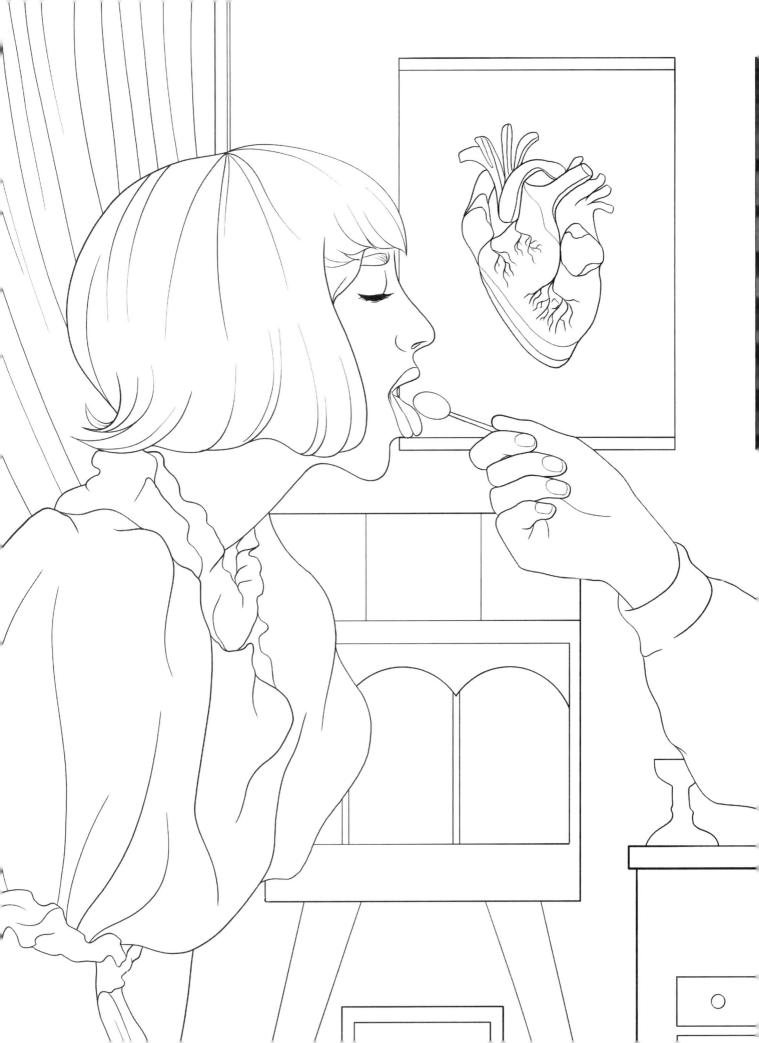

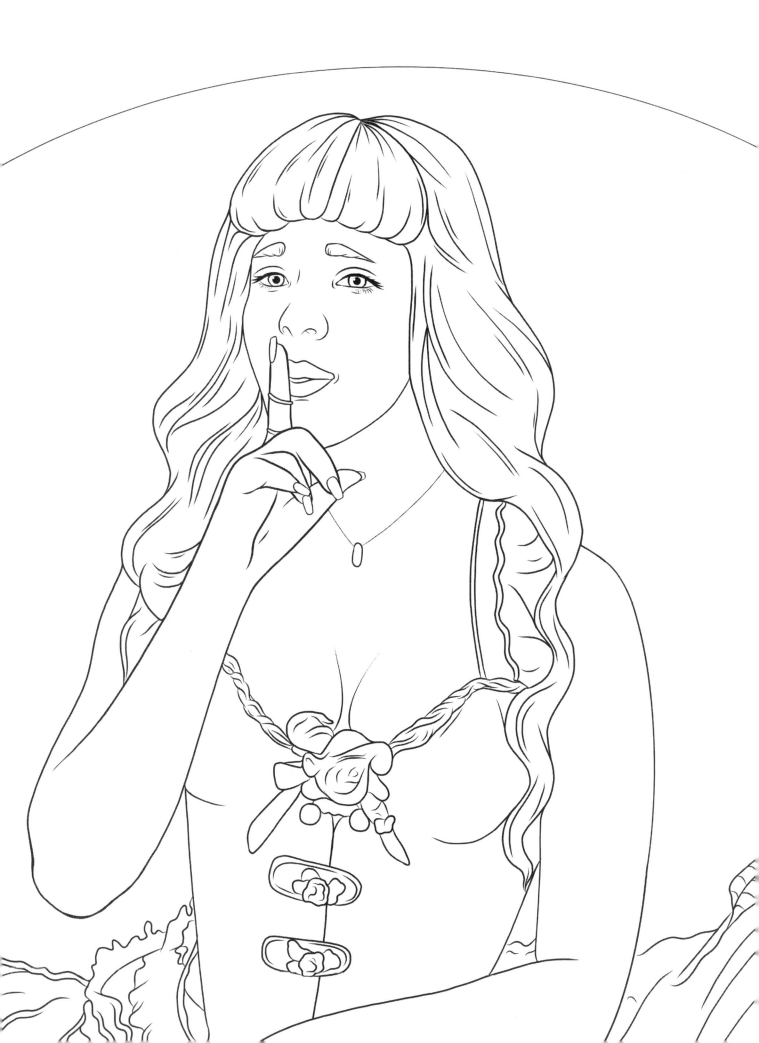

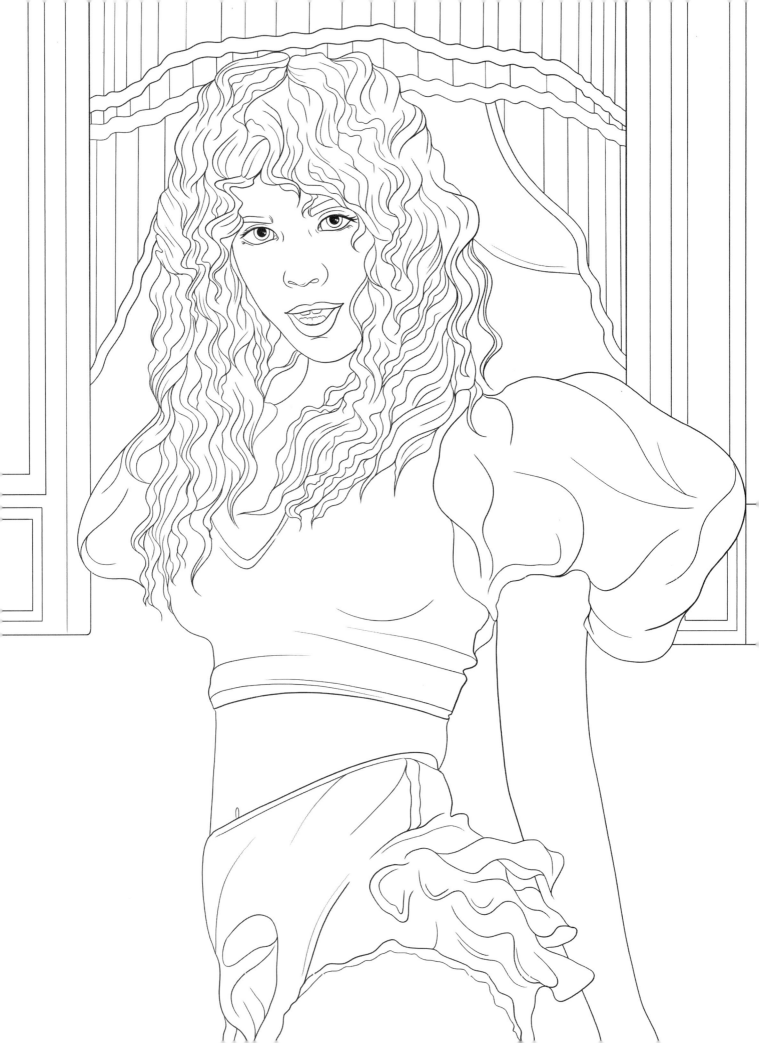

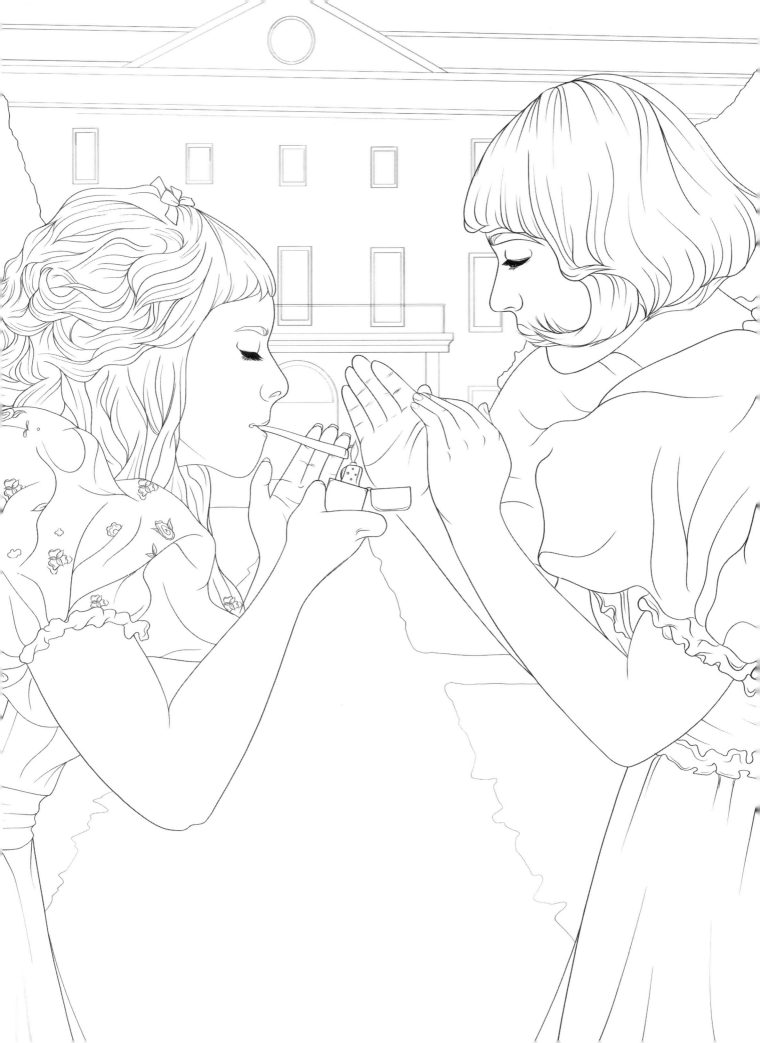

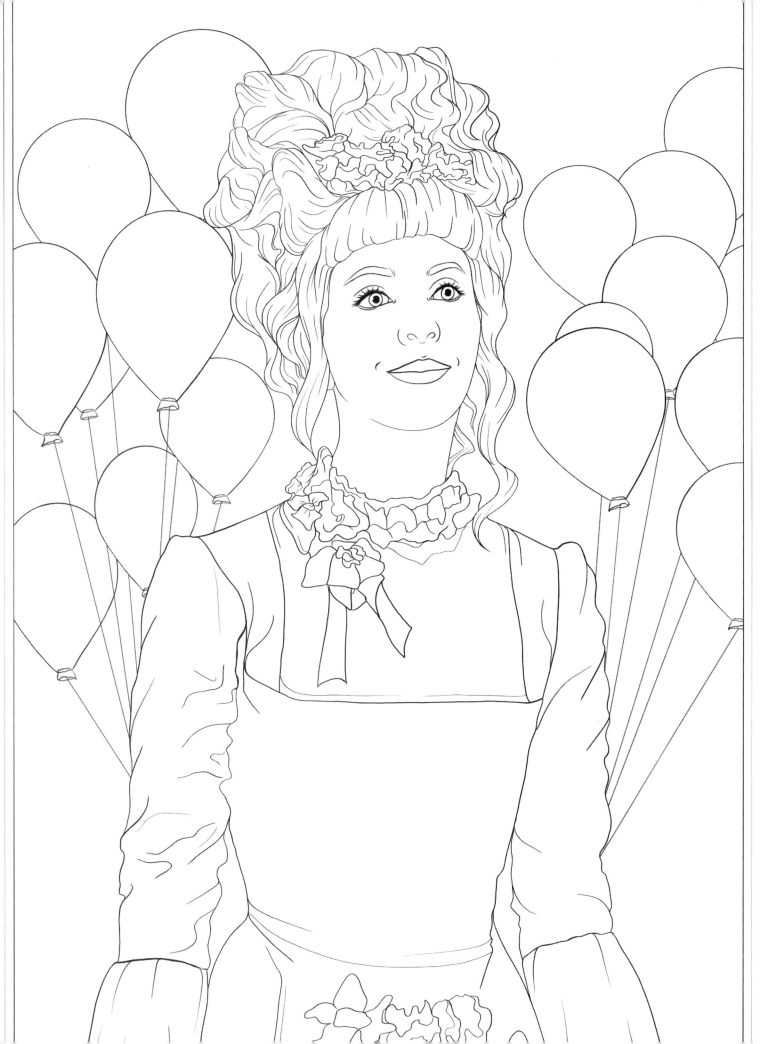

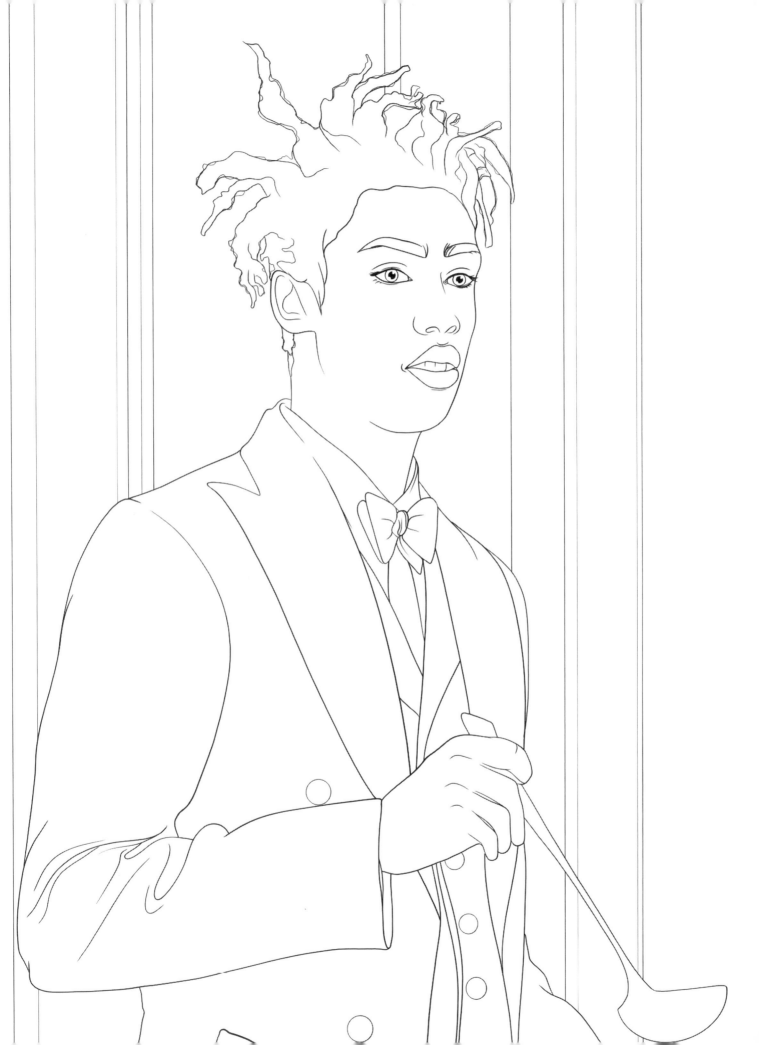

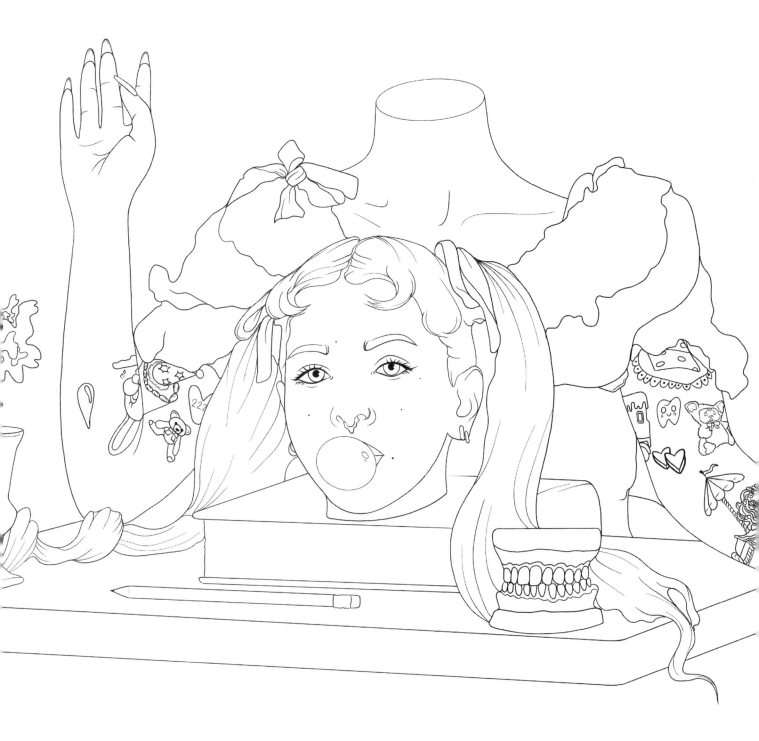

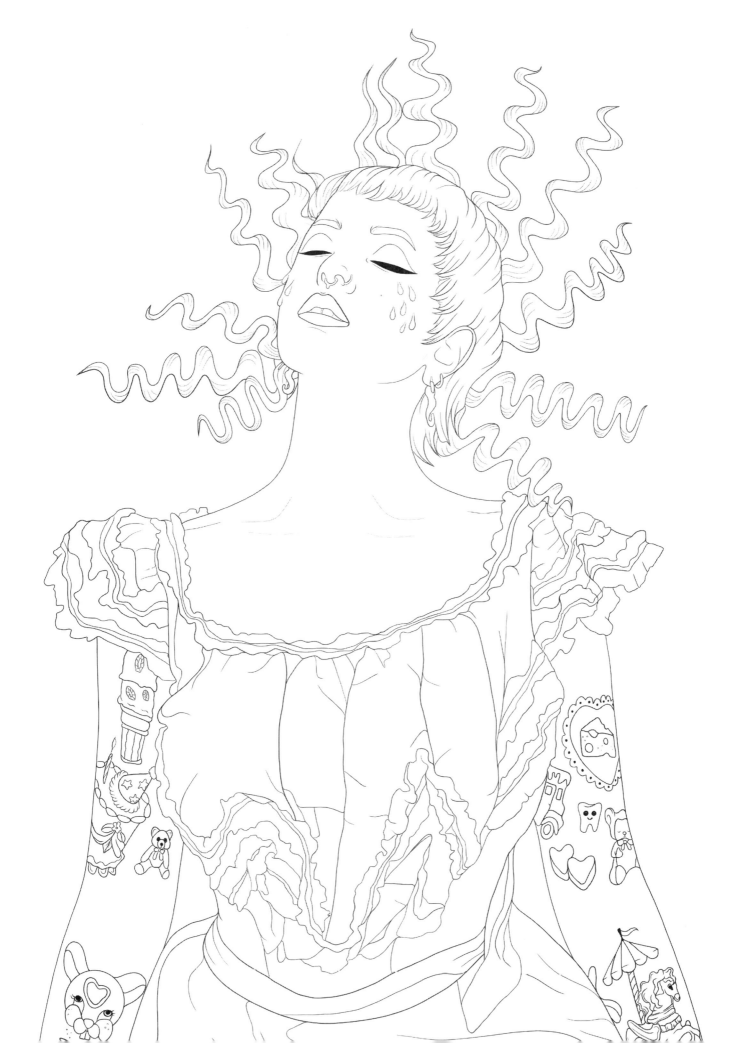

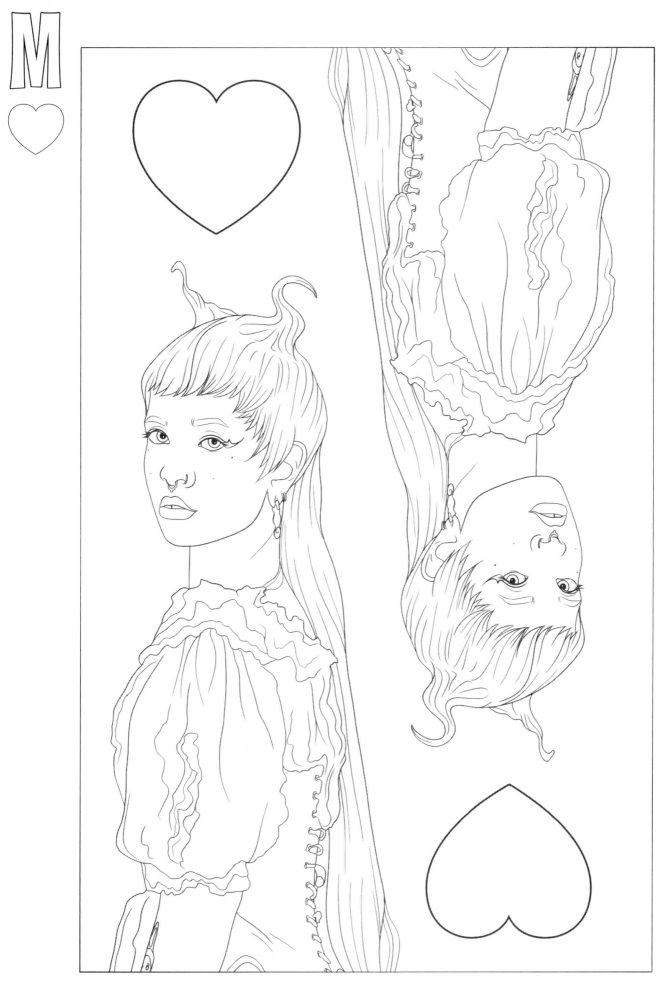

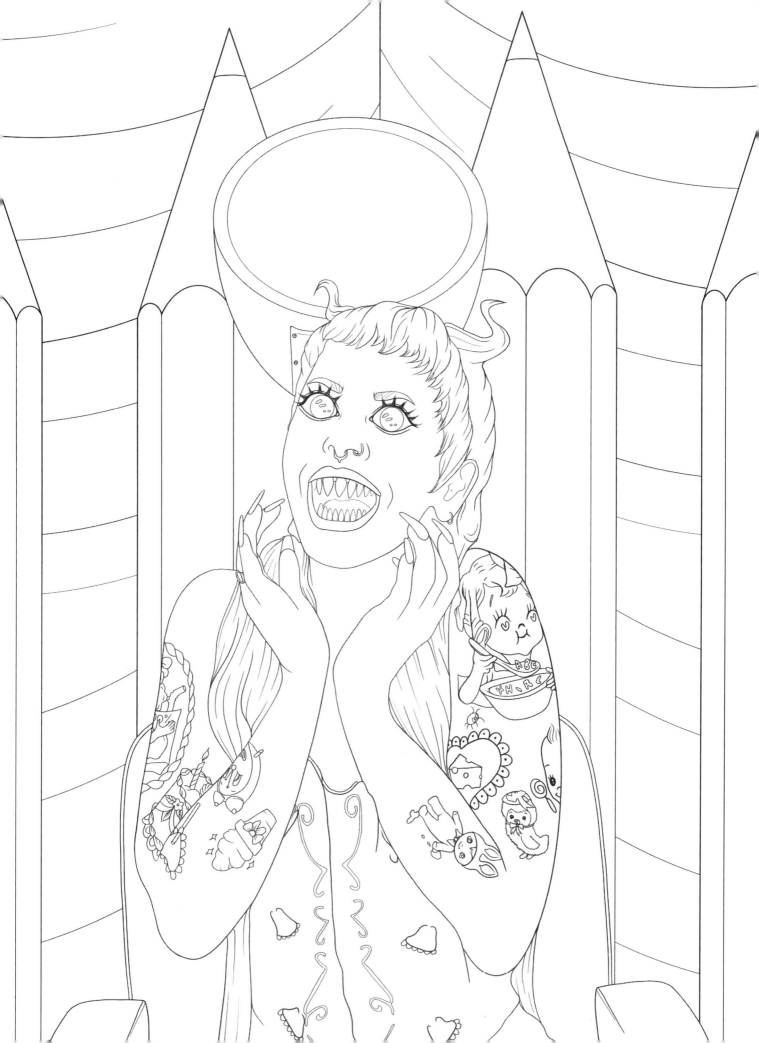

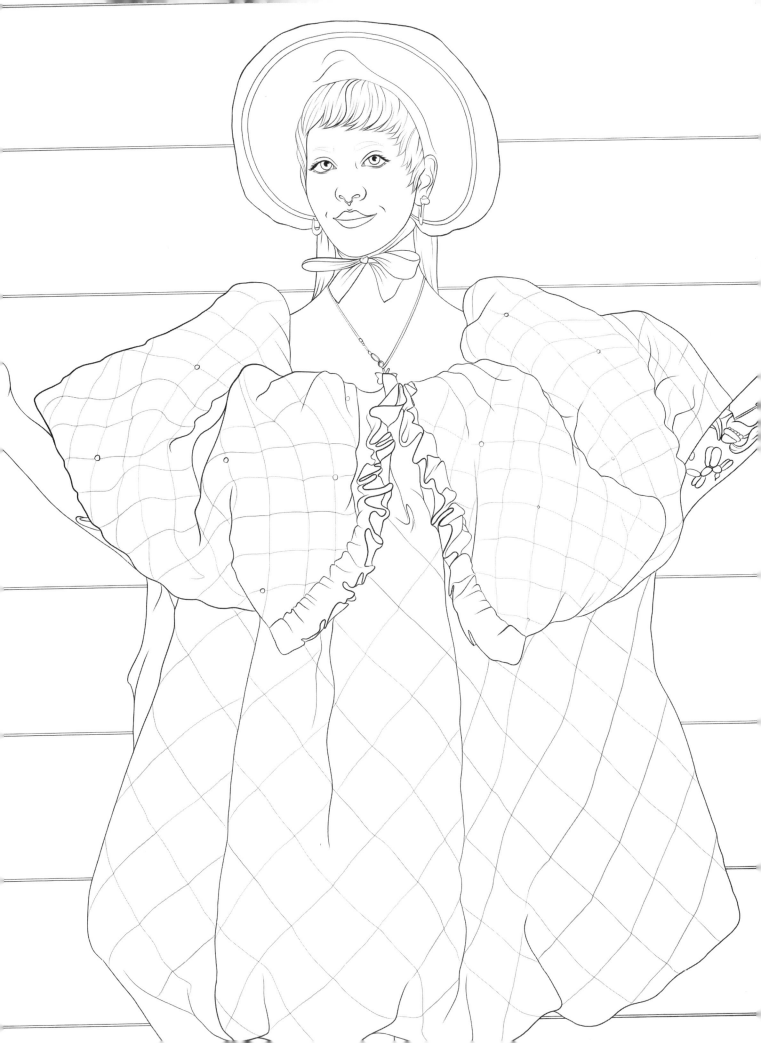